Drawing Dragons

How to Draw Mythical Creatures for the Beginner

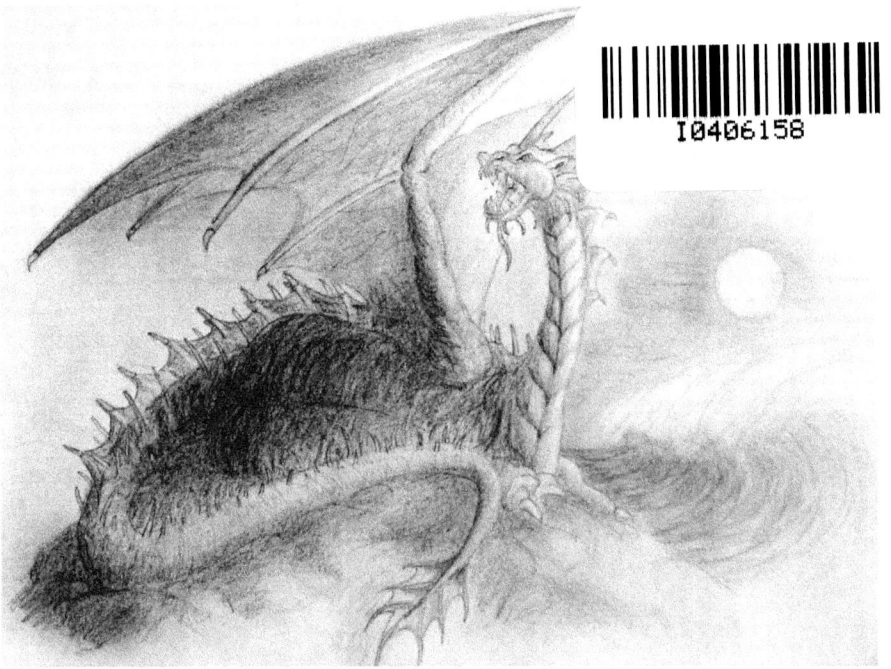

Jonalyn Crisologo and John Davidson

Learn to Draw
Book Series
Mendon Cottage Books
JD- Biz Publishing

All Rights Reserved.
No part of this publication may be reproduced in any form or by any means, including scanning, photocopying, or otherwise without prior written permission from JD-Biz Corp and at http://JD-Biz.com.
Copyright © 2014

All Images Licensed

By: Jonalyn Crisologo and 123rf.com

Learn How to Draw Books for The Absolute Beginner

INTRODUCTION	4
PART I \| DRAGONS: GENERAL FACTS AND FICTION	6
DRAGONS IN EUROPEAN MYTHOLOGY	6
DRAGONS IN ASIAN CULTURE	7
DRAGONS IN MYSTICISM AND RELIGION	8
THE DRAGON REALM	9
ALIENS AND DRAGONS	9
REBIRTH OF DRAGONS IN MODERN ART AND MEDIA	10
PUFF THE FRIENDLY DRAGON	12
ANCIENT SCROLLS AND TATTOO ART	13
PART II \| HOW TO DRAW DRAGONS	15
DRAWING TOOLS	15
THE DRAWING PROCESS	18
SETTING A CREATIVE INTENTION	18
PARTS OF THE DRAGON	20
EASTERN DRAGON	20
Lines, Shapes and Gesture Drawing	*20*
Form Construction - contour	*22*
Detailing	*24*
WESTERN DRAGONS	29
Lines, Shapes and Gesture Drawing	*29*
Form Construction - contour	*33*
Detailing	*35*
RENDERING	38
BASIC RENDERING EXERCISES	39
DRAGON RENDERING	44
GLOSSARY	49
THE AUTHOR	51

Introduction

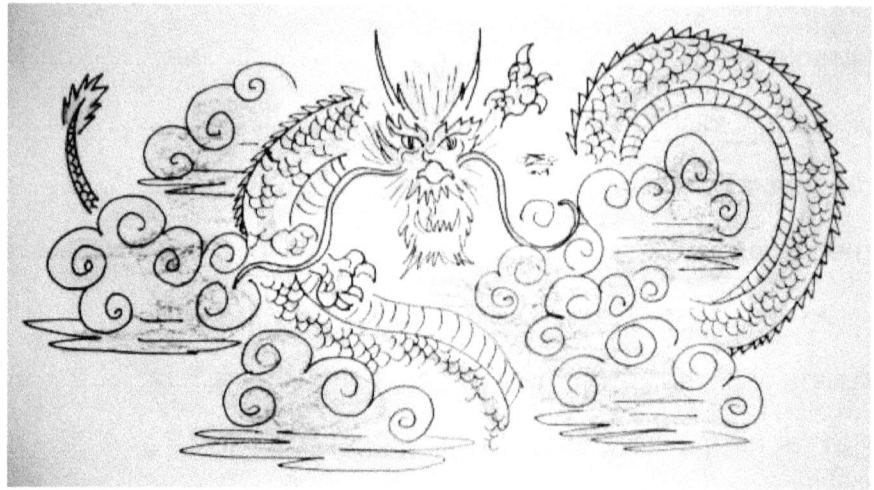

Fantasy has been in existence since time immemorial. From myths that tell of the earth's creation, to folk and old wives' tales that explain life and its mysteries, to bedtime stories that fill the dreams and imaginations of children... they have enthralled audiences of all ages from every era.

One of the most treasured of these fantasy creatures are the dragons. While there is not a trace proving their existence, there is a minefield of precious artifacts that reveal humanity's fascination with them.

Where did they originate? How long had they been around? What caused their disappearance? Maybe the answers will remain a mystery, but an exploration into the world, where fire-breathing creatures come alive, would always be a worthwhile endeavor.

The first of the *How to Draw Mythical Creatures for the Absolute Beginner* series, *Dragons* is divided into two parts. Part One explores the presence of dragons in Art and Pop Culture. Part Two equips novices with the necessary drawing processes and techniques. Using the most basic of tools, you will be provided with straightforward instructions that aim to bolster your creative skills.

Included in the drawing process is a discussion on rendering techniques and exercises. Rudimentary to the beginning artist, the discussion is succinct, direct, yet thorough.

Moreover, a glossary has been included to aid the absolute beginner. This will keep one from getting caught in the trap of confounding words frequently used not only in this book, but also in the drawing community.

May every reader enjoy this delightful guide into the mythical!

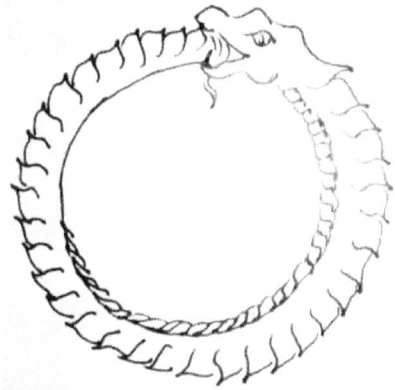

Part I | Dragons: General Facts and Fiction

To debate about the authenticity of dragons is completely out of the question. Anyone can end the argument by one simple statement: Have you seen one? For the sake of debate, we can go on all day, believing that they might have once upon a time existed. Then, perhaps similar to the terrible fate of the Neanderthal men, mammoths, and dinosaurs, their entire species had been obliterated. Unfortunately, there are no skeletal remains or archeological vestiges to prove they have once walked upon the planet and flown across the heavens. However, similar to Atlantis, artifacts in the form of literary and other creative works, chronicle the possibility of their existence.

Without dragons, life seems lackluster, tedious, and insipid. Whether they are the product of vivid imagination or derivatives of other creatures, they bring energies of enthusiasm and exuberance. They have graced palaces, flanked battlefields, enlivened heroic narratives. To this day, they are venerated as symbols of wisdom and power.

In the following sections, we will briefly delve into the Ancient and Modern World of these mythical creatures. Generally, their archaic presence can be divided into two: European (West) and Asian (East).

Dragons in European Mythology

The word dragon finds its roots from the Latin term *draconem* (huge serpent dragon) and the Greek name *drakon* (serpent/giant seafish.) An aptly chosen word, it definitely describes what it is commonly depicted as: a huge reptilian, fire-breathing beast, sheathed with scales. It has clawed arms and feet and leathery, bat-like wings. Beowulf's infamous antagonist is the epitome of European dragon.

Medieval dragon stories commonly revolve around a single plot: a princess is held captive in a castle tower, guarded by the fearsome beast. The damsel in distress is then rescued by a Knight in shining armor or Prince Charming himself.

Similarly, Nordic, Germanic, Slavic, Russian, French and many other European dragons embody the same ferocity and viciousness, in spite

variations in physical appearance.

In contrast, Celtic dragons have long worm-like/serpentine bodies with no wings and legs. Moreover, they are perceived as magical, mystical beings, which contradict the dragons of the East that symbolize wisdom and benevolence.

The Greek variation is commonly known as the *ouroboros*, a tail-devouring creature represented by a creature eating its own tail. This supposedly signifies infinity, recreation, or the eternal return. The influence of the ouroboros on the British and Crusading Knights' dragon-concept can be observed in a number of narratives as the *Lambton Worm* and the *Lernaean Hydra*.

Dragons in Asian Culture

The serpentine representation of the dragon is distinctly prevalent in Chinese and Japanese Art and Literature.

Although other nations associate the Chinese with the dragon, the government refrains from using the image as an insignia due to the aggressive, hostile perceptions that go along with it. However, it remains a common motif prevalent in clothing, utensils, ornaments, decors, walls, and facades. As sculptures of varying sizes, they pockmark gardens and fields.

While other Asian dragons have no apparent distinctions or hierarchy, the Chinese dragons can be distinguished according to their color or number of claws. For instance, dignitaries are represented by three-clawed dragons. However, the emperor is symbolized by a four-clawed dragon. During the Qin Dynasty, the emperor used a five-clawed dragon as his official symbol of power.

Japanese dragons seem to be an offshoot of Chinese, Korean, and Indian legends. They are typically represented as water deities. Similar to the West, the dragon differs from one country to another. They vary in terms of physical appearance and designations.

An interesting myth is one about the origin of the Vietnamese people. According to *The Legend of a Hundred Viets*, the Vietnamese are descendants of a dragon and a fairy. Dragon Prince Lạc Long Quân chanced upon a demonic bird chasing a white crane. The prince came to the crane's rescue. A violent struggle ensued. In the end, the prince prevailed and killed

the dragon. Little did the prince know that the crane turned out to be a fairy, named Âu Cơ, who morphed herself in an attempt to evade her demonic pursuer. Lạc Long Quân and Âu Cơ's friendship blossomed and the two were later married. Their union spawned a hundred sons.

Dragons in Mysticism and Religion

One of the literary treasures of the ancient city of Babylonia (the earliest civilization unearthed by archaeologists) is the creation legend known as *Merodach the Dragon Slayer*. The Father of the Primordial Deep Apsu and the Spirit of Chaos Tiamat conspired against their children, the high gods, who desired to take control of the universe with the purpose of restoring order. In the resulting skirmish, Ea (the God of the Deep) called upon Merodach to battle against Tiamat's forces. Eventually, Merodach was named ruler of the universe.

The dragon is quite prevalent in Christianity. It is mentioned especially in the *Book of Revelations* as a representation of Satan. The most famous portrayal of Satan as a dragon is his defeat at the hands of the Archangel Michael and his Legion of Light. It is for this, that Archangel Michael has been dubbed "The Dragon Slayer." Moreover, he is often called upon in prayer for protection and to cast away negative entities and/or vibrations.

Apart from Christianity, the dragons similarly appear in other world religions. In mysticism, the dragon has been used by occult and underground groups. Unfortunately, it is commonly associated with affiliations that practice Black Magic or are construed to be allied with dark forces.

These underground societies are supposed progenies of the Fall of Atlantis. Purportedly, inhabitants managed to flee Atlantis before it had been completely overtaken by malevolent beings. The "fugitives" hid underground or established new settlements in remote lands, determined to continue on the line and pass on their *traditions* to their descendants. Unfortunately, these newly formed "societies" had been similarly undermined. Once infiltrated, the societies endured, but the traditions had been forever tarnished.

The dragon is also associated with the rising fiery serpent that is reminiscent of the rising kundalini energy. Contrary to popular belief, the kundalini energy has nothing to do with the serpent or dragon itself. Instead, it was so symbolized because of the form the energy takes on: serpent-like as though

ascending a staff.

The Dragon Realm

DJ Conway has authored several books on the five rings of the Dragon realm. Similar to other mystics, she writes about dragons as powerful fire elementals whose energies can be drawn upon.

Apparently, there exists, at least three breeds of dragons: fire-breathers, cold-frost-breathers, and acid breathers. Regardless of which breed you wish to summon, you must be of pure heart, as they only appear to those who are righteous and deserving. You must not be motivated by worldly desires such as conquer, greed, and deceit.

With regards to man's selfish vanities, it is said that the dragon lords could not grasp man's self-sabotaging way of living nor his crave for power. Thus, they withdrew from the eyes of humanity, revealing themselves only to the few deserving truth-seekers.

Others explain that the dragon realm exists in the Tenth Dimension, which is described as a realm of peace. And, that a group of Elders on Earth work with White Dragons to heal and pave the way for planet's ascension.

Moreover, Saint Germain is known to be the first-born dragon. He carries the title *Light Master* and has been quite controversial for his mysterious identity. He had often claimed to be 500 years old or such to elude inquiries regarding his origin. It is for that reason that Voltaire dubbed him "Wonderman." Upon his death, it is said that he revealed himself as the son of Prince Francis II Rakoczi of Transylvania.

Recognized as an alchemist, he is also believed, by mystics, as the Keeper of the Violet Flame (or Violet Ray), which essentially transmutes low energies such as hate, fear, and envy into high energies of peace, joy, and love. This Violet Flame supposedly plays a vital role in the Age of Aquarius, which will usher in the Golden Age of the planet Earth.

Aliens and Dragons

On one hand, mystics put dragons in the light as wise and powerful beings.

On the other hand, E.T. enthusiasts write of serpentine/reptilian-like creatures from other planets. Interestingly, these alien species bear the name which resembles the Greek origin of the word: *Draconia*.

The Alpha-Draconians, Altairians, Chameleons, Dracos, and Draco-Borgs are only some of these controversial entities. Unfortunately, unlike the dwellers of the Tenth Dimension, they have malicious intents of completely annihilating the human race.

Despite their presence on the planet (approximately over 5,000 years), it is said that these extraterrestrials have not desired to bring about an all-out war with mankind due to their inferior technologies to the Arcturians—one of the most advanced fifth-dimensional beings in the universe—who help protect the Earth. Instead, the malevolent reptilian extraterrestrials work with The Grays (commonly depicted in films as wide-eyed, gray-skinned telepaths of an imposing stature), who have infiltrated the seats of power in the planet.

With regards to the truth about aliens, man remains oblivious to their existence just as he is towards that of divine elementals. And yet, these creatures remain a delight for daydreams, novels, and films.

Rebirth of Dragons in Modern Art and Media

Dragons are featured not only in films, books, and visual art, but also in digital art and applications. Many digital games, especially those whose constructs are built around the medieval concept, feature this fire-breathing beast.

In the past couple of years, the precedence of the mythical creature has been reinforced by their appearance in George Martin's acclaimed epic saga, Game of Thrones. The siblings Viserys and Daenerys are the last progeny of House of Targaryen. Forced to flee their home at a tender age, they had spent most of their lives on the run. Viserys' contempt and desire for revenge, compels him to force Daenerys to wed Khal Drogo, a fearsome and powerful warlord of the Dothraki tribe, on the promise of a crown and army to win back the iron seat of Westeros. On their wedding day, Daenerys is presented with three exquisite dragon eggs, supposed to be rocks. However, it is later revealed that the dragon eggs had been real after all. This helps

Daenerys gain power and recognition after her husband's unfortunate demise.

The *Inheritance Cycle,* a series penned by Christopher Paolini, is another famous work that has been turned into a film. Similar to George Martin's opus, the first book entitled *Eragon* takes place in an era where dragons and their riders believed to be myths and the probabilities of their existence forbidden. Eragon changes this when he stumbles upon a dragon egg, raises it, and trains to become a rider.

Another remarkable film is *Tales from the Earthsea* (based on the series authored by Ursula K. Le Guin entitled "Earthsea.") The story concept was developed by acclaimed Japanese Animator and Filmmaker Hayao Miyazaki. The screenplay and direction was spearheaded by Director and Landscaper Goro Miyazaki.

Tales of the Earthsea reiterates mythical ideologies of the origins of dragons. A ship's weather worker witnesses an ensuing battle between two dragons in the sky. The skirmish ends with the death of one dragon. The weather worker is distraught, as such an ineffable event had been believed impossible—dragons are eternal cosmic beings.

The king receives word of the bad omen at sea, together with the disappearance of his son. He is confounded by the situation as the kingdom has been plagued by a series of catastrophes, with people going delirious.

Thus, he seeks the counsel of the wizard, who enlightens him of the ancient times when man and dragon had been as "one." Until the schism, men who chose freedom transcended their human form to become dragons. Those who chose material desire remained on earth, separated forever from the dragons. The evil besetting the kingdom must have been caused by the disturbance of the natural flow and balance of the world. But, before the king could resolve such quandaries, he meets an unfortunate end at the hands of his very own son.

Outside the kingdom, a wandering wizard is bemused by the dragon sightings. Apart from being immortal, dragons had long withdrawn from the human world—they are not supposed to be on Earth. Taken by his curiosity, he embarks on a quest to determine the cause. This is how he crosses paths with the young prince. Apparently, the latter possesses a furtive dark side that yields immense powers, of such magnitude and ferocity, for which the prince falls prey to a witch, who cunningly uses his "fears" to her advantage—deviously turning the prince and the wandering wizard against

each other.

It is worth noting that Hayao Miyazaki's works are symbolic and reflective, bringing to life archaic philosophies. They subtly advocate the love of nature and the oneness of creation. This is observed in *Spirited Away*, where good and bad co-exist in one domain. Throughout her ordeals, the heroine is aided by a dweller of the enigmatic realm, who turns out to be a Water Dragon—the spirit of the Kohaku River.

Puff the Friendly Dragon

Children's fairy tales and folklore had not been very sympathetic towards dragons. However, these fire-breathing beasts found a soft spot in the hearts of modern day storytellers. Animated films and television shows have begun portraying them as misunderstood creatures. Perhaps the most famous friendly dragon in pop culture would be none other than Puff. You got it right: Puff of Hanalee, Jacky Paper's buddy.

Puff the Magic Dragon is based on a poem Leonard Lipton wrote a few years prior to the song's release. He was inspired by Ogden Nash's *Custard the Dragon*. During his years in Cornell, Leonard lived with Peter Yarrow. Using Peter's typewriter, he came up with the poem.

A few years later, Yarrow would meet Paul Stookey and Mary Travers and form the musical trio known as Peter, Paul and Mary. The folk-singing group recorded and released the song in 1962, making it a sensational hit. Unfortunately, having been released at a revolutionary era, Puff received criticisms for its alleged symbolism.

Towards the end, the song declares the sad reality that, as children grow up they outgrow their childhood fancies. This happened when Jackie Paper failed to visit Puff. In his desolation and solitude, Puff withdrew to his cave. However farfetched, could these verses of the song be the key behind the mysterious disappearance of dragons?

Believer or nonbeliever, dragons are indeed exquisite and enchanting for the marvelous tales and mysteries they hold. While we may never find the door that leads to the secret refuge of these mystical beings, there is one door we can definitely walk into in a few seconds: that which contains tips and tricks to creating our own dragon.

Ancient Scrolls and Tattoo Art

To prepare us for the next segment of this book, let us take a look at some magnum opus depicting dragons. We glimpse Ancient Dragon Artistry and pay homage to one of the most acclaimed artists, who has made his mark in Tattoo Art—the prevailing modern art form that venerates dragons as its subject.

To celebrate the turn of the century, renowned Tattoo Artist Ed Hardy's *2000 Dragons Scroll* was displayed at the Track 16 Gallery in Santa Monica, California. The year 2000 was a Year of the Dragon. Thus, Hardy deemed it fitting for the exhibit. He prepared the scroll, measuring four feet by 500 feet. He explains that the idea was inspired by the work of Chinese Dragon Painter Chen Rong (or Che'en Jun, ca. 1200-1266), of the Sung Dynasty.

It is known that scroll paintings have been revered in Asian tradition for centuries. The most remarkable work of Chen Rong, the *Nine Dragon Scroll*" is currently housed in the Boston Museum of Fine Arts.

Cheng's scroll is a visual narration, telling of the cosmic paradigm. The dragons and enveloping clouds appear as colossal spiraling, writhing energies tantamount to spinning nebulas, atoms, or even that of the human heart and mind. It seems to articulate that such passionate, intense forces sprung forth life; and the same preserves all of creation.

In the paintings, the dragons appear to dwell in the midst of these primordial tempests of elements. And, the immortality of the beings is reminiscent of ancient ideology that all is energy and energy is eternal—ultimately suggesting the immortality of the human soul and all of creation.

Prior to reaching its present abode, the *Nine Dragons Scroll* had been well preserved by Taoist chief priests and Chinese emperors, who had esteemed Cheng's masterpiece. It is now a wonder, for the *Scroll* personifies their core teachings and profoundly reiterates the force behind the mysteries of the universe.

The famed Japanese Artist Hokusai similarly demonstrates a symbolic rendition in his magnum opus, *The Dragon of Smoke Escaping from Mount Fuji*. Hokusai is well-known for his artworks that often depict Mount Fuji.

In this specific painting, a black dragon emerges, masked by a cloud of smoke. Its apparition is contrasted by the majestic Mount Fuji—its snow-capped mountain top covered an immaculate white. It rises amidst foothills and dwarfs foliage on the foreground. Truly a master craftsman, Hokusai's work seems to encompass the wisdom and values of the Japanese people regarding nature and mythical creatures.

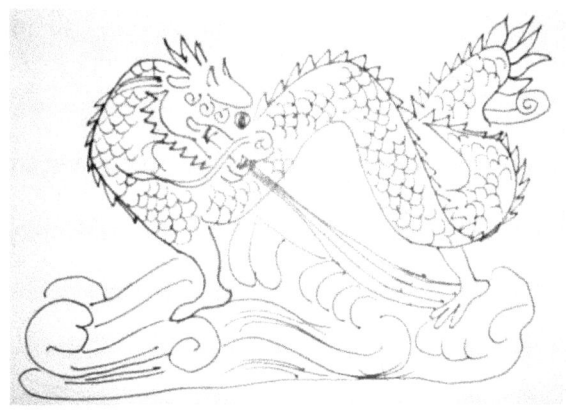

Part II | How to Draw Dragons

Drawing Tools

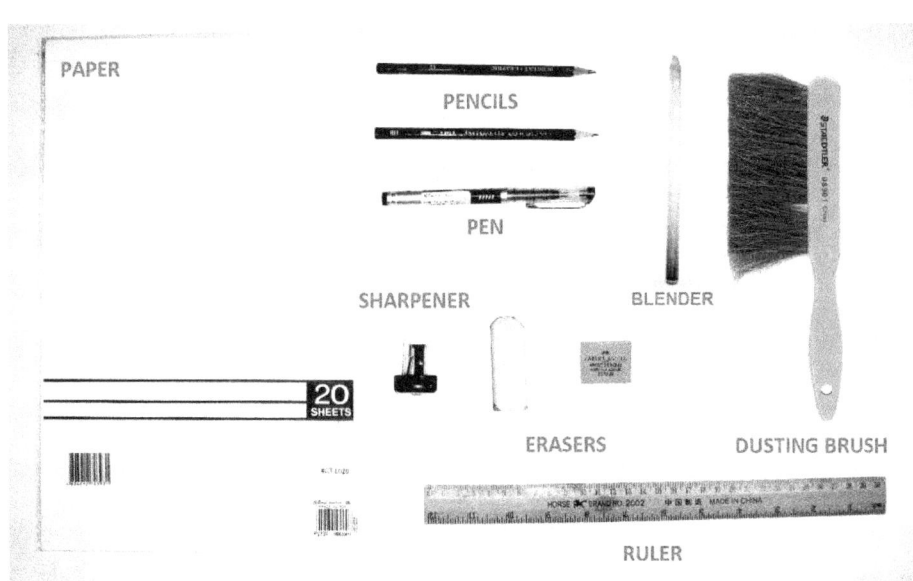

Fig. 1. Drawing tools.

Pencils. Graphite pencils range from H to 6B. B pencils have less clay content and more graphite. Thus, they provide a darker range of value than F and H pencils—H being the lightest. For this course, we will only need three

pencils: 4H, HB and 6B. If you can get a lighter pencil, an F, that will be perfect. If only an HB pencil is available at the moment, simply vary the pressure exerted on your pencil to lighten or darken your strokes.

Pen. Similar to pencils, pens now come in many kinds. Many brands have designed a wide range of pens for designers, engineers, and architectures. These pens do not only vary in ink content, but also vary in point size and material. Take felt pens or gel pens that come in 0.5 or 0.7 mm. I personally love the texture of felt pens. But I do not recommend them for this course. Instead, opt for a gel or roller-tip ink pen with a point size of 0.7 mm. For our purpose, these are more affordable and practical than felt pens.

Erasers. You will want to work with a regular vinyl eraser and a kneaded eraser. The vinyl eraser will be used to remove mistakes the way one normally does. The kneaded eraser will be used for miniscule details. The best thing about kneaded erasers, which you will eventually find handy, is that you could mold it into different sizes depending on your needs.

Some brands manufacture PVC-free erasers. These do not produce dust particles, which are a nuisance. Moreover, they do not chafe the surface of the paper due to too much erasing. Most of all, they do not contain chemicals harmful to the environment. I highly recommend working with PVC-free and kneaded erasers. But if you cannot find these, a vinyl eraser will do.

Sharpener. Have a reliable sharpening tool by your side at all times. You never know when your pencils might break. Most of all, it is important to always sharpen your tools and keep them from blunting. Well-sharpened pencils provide precise lines compared to blunt points.

Paper. For this course, I recommend a rim of bond paper over a sketchpad. We will also need some tracing paper. We will literally draw in layers (something we will discuss later.)

Ruler. Rulers are fairly basic. Many professions that involve some form of drawing or measuring use rulers. These jobs are not limited to engineering, architecture, or carpentry. As an artist, you will find the ruler is quite a companion—an indispensable instrument in your tool box. While most freehand drawings will not require the use of rulers, you will find it will always come in handy. You just never know when you will need it.

There are many types of rulers. There are expensive sturdy ones. There are cheap, transparent or wooden ones. Find what works best for you. And,

most importantly, invest in a good one that will serve you well.

Tortillon, blending stump, blender, and brush. A number of items can be used as blending tools such as a ball of cotton and scrap of leather or suede—but never use your fingers, no matter how tempting. Using your finger comes naturally. However, it is not advisable because the finger covers a large amount of space, smearing your work where you do not necessarily want them.

The tortillon is the most common blending tool. It is also called a blending stump or smudge stick. It comes in different sizes. This makes it comfortable for your grip and also gives you several options to choose from. Remember never to use a pencil sharpener or cutter to sharpen your tortillon, rather, when they get blunt, use sandpaper to sharpen them.

Some brands now manufacture pencil-like blenders that allow you to simply sharpen them just like pencils. I currently use a Derwent blender. Find what works best for you.

Some prefer using a brush for blending. Still, others use both for variety. The difference? The tortillon blends definite regions on your work. The brush indiscriminately sweeps over an area. Brushes are either synthetic (nylon or other synthetic fibers) or natural (animal hair). Brushes made with synthetic fibers are easier to maintain and tend to last longer than brushes made with natural hair.

Brushes come in an assortment of sizes and shapes. Rounded brushes are used for lighter pressure, while flat brushes are used to create darker tones and hard edges.
For blending, a size 1 and 2 flat nylon brush will do.

Dusting brush. Usually, dusts caused by erasing are just brushed aside with a hand. This is not advisable because you can smear your drawings. Using a dusting brush avoids creating unnecessary smudges. Better yet, you might want to invest in PVC-free erasers, which are as affordable as ordinary erasers.

OPTIONAL: Coloring Materials. There are a multitude of options available, from crayons, to pastels, to watercolor. Take your pick. Prismacolor pens are a wonderful choice because of the brilliant, watercolor-quality. And yet they are more versatile than watercolor. As you advance, explore the digital tools now available for artists. Considering the laborious tasks of The Artist, going digital is worth pondering. However,

remember that the tools are not as relevant as learning the techniques. A true craftsman can work with just about any medium and still deliver quality results.

The Drawing Process

Setting a Creative Intention

Prior to laying out your tools, defining your intention is the first step towards creation.

It is arguable that some (or most) artists simply start working with no idea of what exactly they will be creating. As Chuck Close quipped:

> *Inspiration is for amateurs; the rest of us just show up and get to work.*

This is true. At times, artists are just bursting with ideas they cannot keep still or leave their work. They will not settle down until they have manifested that which desires to escape the confines of their imagination.

Other times, they frantically search for inspiration, while prying every nook and cranny and squeezing their brain cells for creative juices. Until something miraculously happens: the very act of searching patiently and persistently yields illumination—not just a eureka moment with a light bulb popping above the head, but a divine enlightenment that gives birth to a masterpiece.

Whether or not an artist begins work with a concrete idea in mind, this is what has to be understood: every artist starts out with intent.

Before even lifting a pen, setting up a canvas, or selecting a color, an artist has already set an intention in mind. And what exactly is this intention? The intention is to create. The artist wakes up, shows up, and settles in with that one thought: **I will create**.

And when there are no ideas, the artist believes that there is a universe filled with ideas. All that needs to be done is to start creating.

As for you, you have already had your intention long before you got to this page—long before we began the drawing process. You have chosen to read this book because of a very specific intention. Why, of course, it is none

other than to draw dragons! There is this creative thought bursting, an inner dragon inside of you that simply wants to come out and come to life.

Feel that dragon inside of you. What does it look like? What are the colors of its whiskers and scales? Does it have a name? Just by asking these questions, you just made your intention even more specific than it already was and the inner desire to manifest is even more urgent by now. So, let us cut all this talk and proceed!

Drawing in Layers

If you ever attempted creating digital graphics or using graphic-editing programs such as Adobe Photoshop, you are probably familiar with working with layers. The drawing process we will adopt in this course uses the same technique: Drawing in layers.

What does "drawing in layers" mean? It is starting out with a quick sketch of the form and then developing on this by adding details. You will want to work this way instead of starting with one area (usually the head/upper portion of a drawing), drawing in elaborate details, and then working your way down only to realize by the time you get to the lower extremities that there is no room for the rest of the body or, worse yet, that your drawing is ill-proportioned.

The process of drawing in layers usually takes three steps: sketching the figures, constructing the forms, and finalizing the details.

Anatomical Structure and Proportion

To be quite frank, no one can actually draw a well-structured dragon. Why? Most (or should we say all?) humans have not seen any for real! All sculptures and drawings are based by studying ancient works and developing on these "prototypes." Thus, there is no solid foundation by which anyone can learn more about their structure and composition.

However, you might have wondered yourself why you are unable to create a well-proportioned dragon. If they do not exist, why does your own mind perceive something completely off and wrong about your drawing? That is because something may indeed be wrong. Remember, the number one rule in drawing can be summarized in a few words: If it looks wrong, it must be wrong. No worries. We will be discussing a number of tips that serve as

helpful guides to the effective conceptualization and construction of a dragon.

The good news is this means we can stretch our imagination. Think about the film *How to Train Your Dragon* and the many possibilities one can actually come up with! So, depending on what type of drawing you are working on, anything is virtually possible! There are no limits!

Parts of the Dragon

Let us proceed with the main focus of this course by narrowing down on two specific established concepts of what dragons look like: the Eastern and Western dragons. Let us start with the first.

Eastern Dragon

Lines, Shapes and Gesture Drawing

I decided to create a dragon based on the traditional Chinese figure commonly seen in Modern Tattoo Art. Typically, these are the parts of a Chinese dragon to watch out for:

Camel or Horse Head
Hare Eyes
Bull Ears
Deer or Stag Horns
Snake Neck
Carp or Fish Scales
Belly Clam
Tiger Paws
Eagle Claws
Rabbit Ears

There is no apparent restriction to the length of a dragon. The lengthier they are, the more entangled in swirls the body will appear. The length of the neck allows room for long whirling whiskers. The belly can be a noticeable bulge; or it can be flat and inconspicuous.

Let us go back to intention. Remember what came to mind earlier. Imagine

your dragon flying across the sky. Now using your mind's camera, capture a specific image that you want to put into paper. For this demonstration, I chose a Chinese dragon with a bit of modern twist.

Using that image, establish the form by drawing the *line of action*. The line of action is primarily used in Figure Drawing, but it has its uses in other types of drawings. It is especially useful in full-paged drawings as well as for media that allow little room for correction. An excellent example is Tattoo and Ballpoint Pen Art. Both media have little tolerance for mistake. But that is the very reason both are excellent platforms that help artists broaden their imagination.

What is the line of action? It is a straight, curved, swirling line that marks out the path in which the action or form of a subject will run along. In actuality, it is a simple line that literally makes no sense to an onlooker until we start building on it. Here's what the line of action will look like:

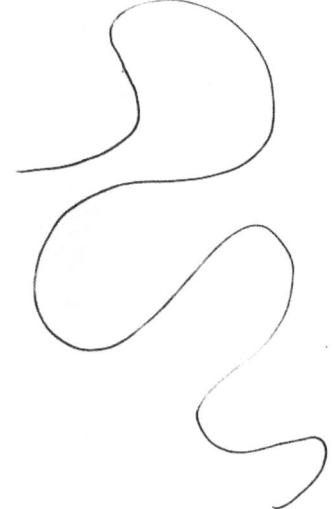

Fig. 2. Line of action.

After drawing the line of action, mark the location of key the features (such as the head, arms, legs, and claws) using geometrical shapes. These shapes serve as our guides, which we can alter at any given point. The advantage of working in layers instead of working on one aspect of a drawing at a time is that revision comes easier. The more complicated a drawing gets, the more difficult it is to make corrections.

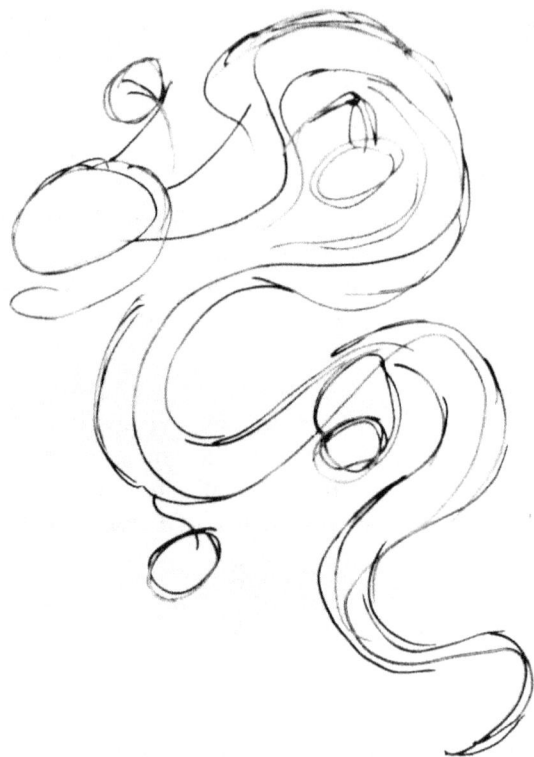

Fig. 3. Basic dragon form.

Form Construction - contour

Begin molding the base form and giving it more shape by drawing in specific details. Establish the breadth and dimensions at this point. Draw in essential features (eyes, ears, horns, fangs, whiskers, arms, legs, and claws).

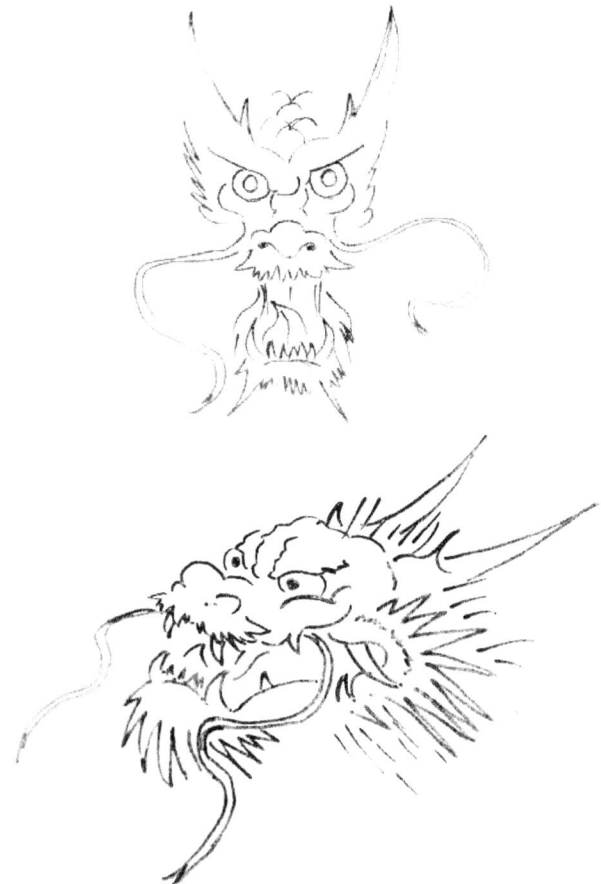

Fig. 4. Samples of Eastern dragon heads.

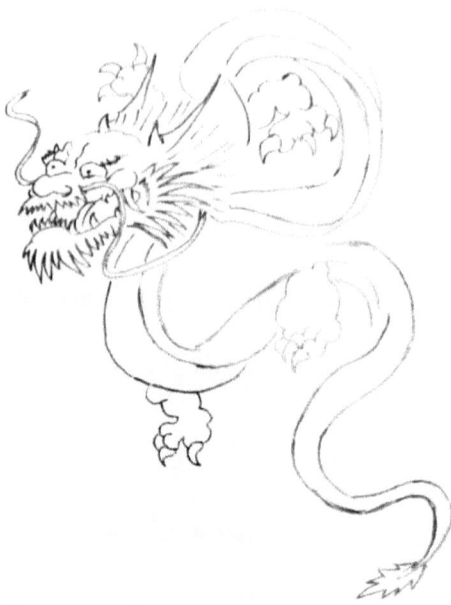

Fig. 5. A more defined structure.

Detailing

As the word implies, we want to establish more details at this point. Define the primary features constructed in the previous step.

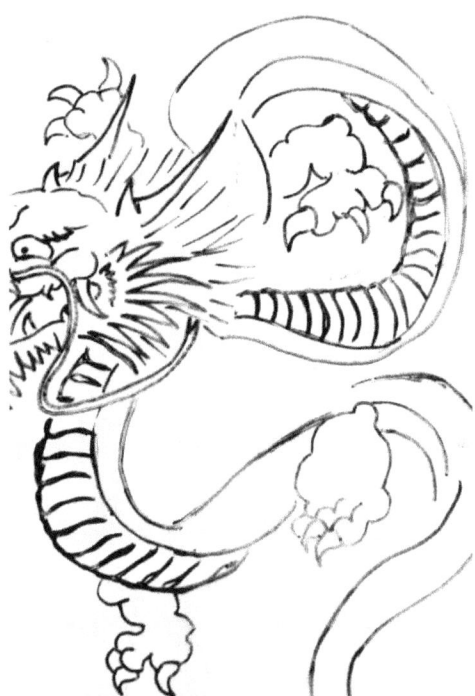

Fig. 6. Draw alternating lines on the area from the neck, belly, and down to the tail. In this case, the perspective only allows for the "front-side" to appear up to the belly.

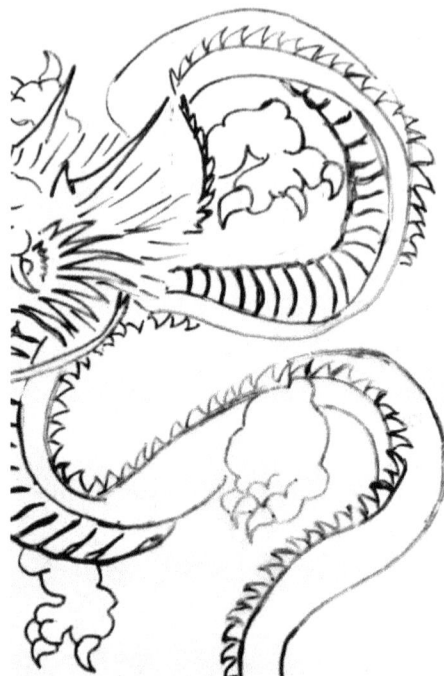

Fig. 7. The back is pockmarked with sharp edges from the neck down to the tail.

Finally, draw the scales. Here is a simple trick to drawing scales:

1. Fill the area for the body with intersecting diagonal lines. This will look like a pattern of diamonds.

2. Then, replace each sharp corner with curved lines to make them look more like scales. This is the most tedious part. I encourage you to be patient and refine one scale at a time, instead of going back and revising should you notice any mistakes.

Fig. 8. Draw a pattern of diagonal lines. Then, draw curved lines over the pattern.

Fig. 9. Filling the entire body with scales tends to make your drawing to appear. One workaround to avoid this is "not to draw all scales." Put gaps in between. This is a technique you can apply even on realistic renditions.

Now that we have finished with penciling, we can proceed with outlining and coloring. Simply trace with a pen. As for your choice of color, you can refer to Chinese symbolism. Ancient texts show that this was one key aspect used for identification. Then again, it would be excellent practice to unleash your creativity at this point. You can take a sheet of tracing paper and place it over your drawing. This way, you can reserve the original drawing as a template and create copies by simply tracing over it.

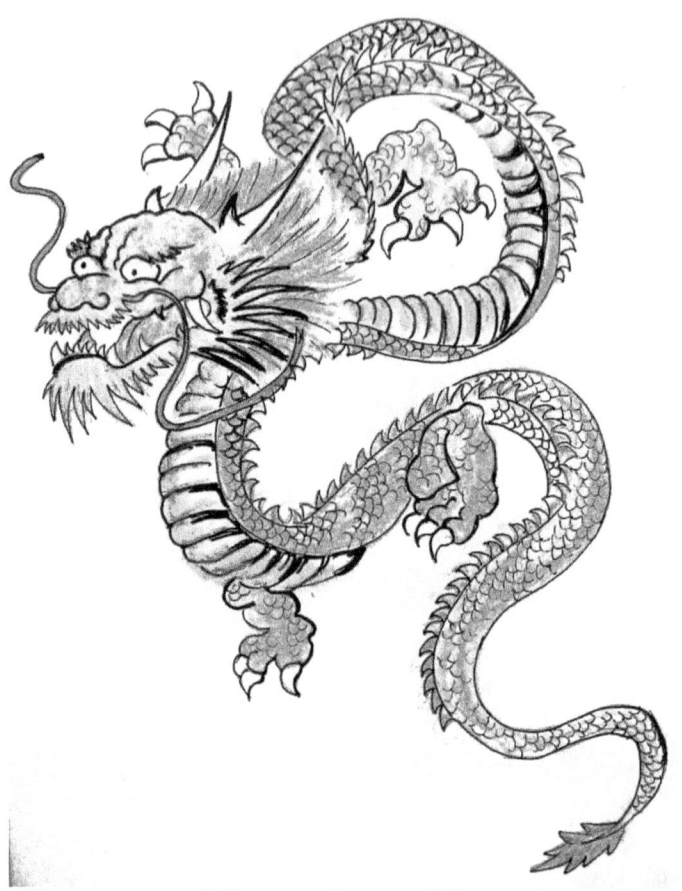

Fig 10. Chinese-inspired Eastern dragon. When coloring for a client or personal project, research on color symbolisms that may exist for each culture (such as the Chinese.) Otherwise, get creative!

As you progress and should you opt to explore other traditional media, consider the possibilities of watercolor and acrylic. When using paper or canvas, the fluidity of paint is quite ideal for creating Asian dragons.

Western Dragons

Lines, Shapes and Gesture Drawing

Quite the opposite of the Eastern dragon's two-dimensional image, the Western dragon's stature leans toward the realistic. I chose the common image predominantly used. We have fewer body features to work with, but the process can be quite more taxing, depending on how realistic you want it to get.

Horns or fan-like appendages
Reptilian body typically resembles a Tyrannosaurus Rex
Dinosaur-like legs and arms
Bat-like wings
Scales

Before we start drawing, let us discuss more about the wings. Some artists choose to combine the arms and wings. Doing so actually makes a lot of sense, because drawing another set of arms means your dragon has two set of arms. Then again, it is futile debating over anatomical makeup unless you have seen an actual dragon (fossil or living.)

The wings are similar to that of a bat. The skeletal structure is comparable to the human arm. Take a look at this:

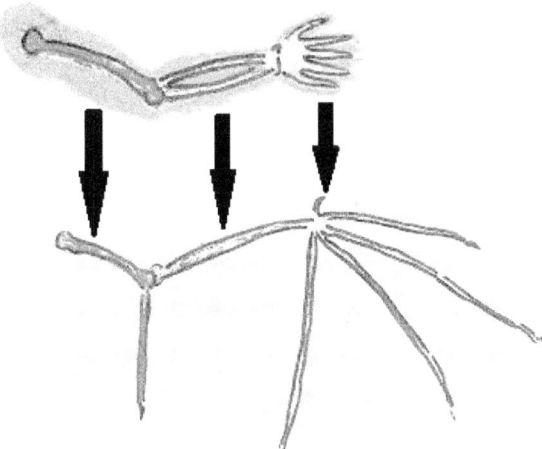

Fig. 11. Comparison between a human arm and dragon wings.

It can be divided into three parts: the upper arm, lower arm, and fingers.

The proportion of the wings can only be estimated. Remember the simple rule: if it looks wrong, it is wrong. One thing to point out is that they are never made too large, to the point of dominating the entire image. There must be some sense of balance between the wings and the body.

However, there is an exemption to this concept of balance. It is a fact that a dragon's wingspan (or the enormity of its wings) seems to be directly related to the degree of intimidation and magnitude of terror it breeds. Take a look at *The Lord of the Rings*' infamous Smaug. Now compare Smaug to *Shrek's* Dragon. Smaug's appearance is arguably more formidable than Dragon regardless of wing size. But if the two were flying from a distance… size indeed matters at some point. Moreover, there still exists a sense of balance and symmetry. Take the time to study and scrutinize. After all, learning to draw is really about *learning how to see*. Artists are inherently observant. They have this innate visual acuity that allows them to perceive the world differently. And somehow this ability can be linked to their desire to recreate or interpret the outside world through their works. It allows the artists to perceive. It triggers enlightenment and inspiration. And it shapes the visual interpretation or manifestation of that which was originally just a concept. Ultimately, this is the attitude that aspiring artists need to develop if they really want to improve their creativity.

Similarly, the lower extremities must not stand out. While the bottom part of the dragon is typically massive, study the structure and ensure that there is a sense of balance. Check out these barebones structures in the form of geometrical shape:

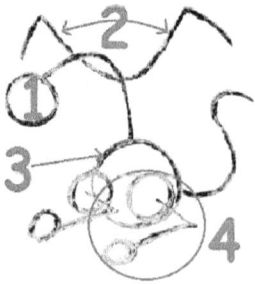

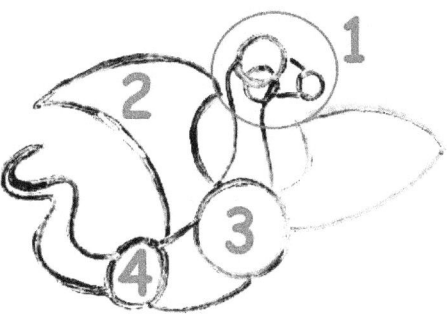

Fig. 12. Left: 1) head, 2) wings, 3) belly, 4) hip bone, legs, knee, and foot. Right: 1) head, 2) wings, 3) belly, 4) hip.

A good tip is to set your drawing aside for a few minutes. You might want to go for a coffee break, step out and breathe in some fresh air, or even take off and run some errands. Do not worry about the drawing. It will not run away. It will be right where you left it.

Completely forgetting about it for a while enables you to look at your drawing from a fresh perspective. This allows you to see flaws or areas you would like to improve on, which you might have completely missed if you had dwelled on it and remained focused on completing your work.

Now, let us get on with drawing our own European-style dragon. Similar to the previous process, develop the image in your mind. Then, draw the line of action using a light-grade pencil.

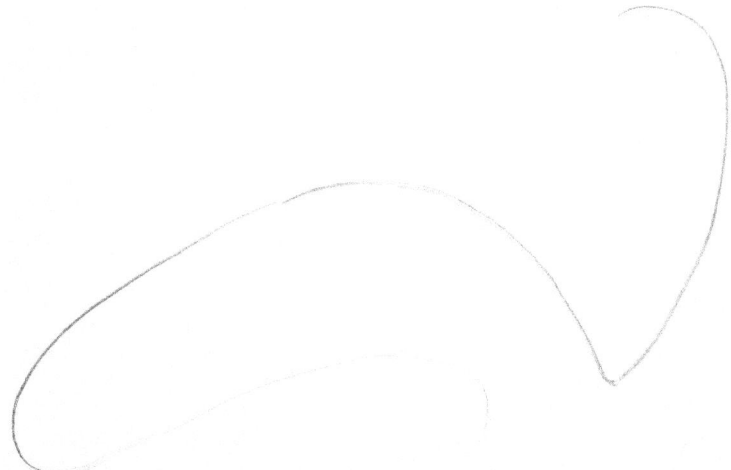

Fig. 13. The line of action may appear simpler than this, depending on the "pose" of your subject or "look" you wish to achieve.

Plot the key features (head, wings, arms, and legs.)

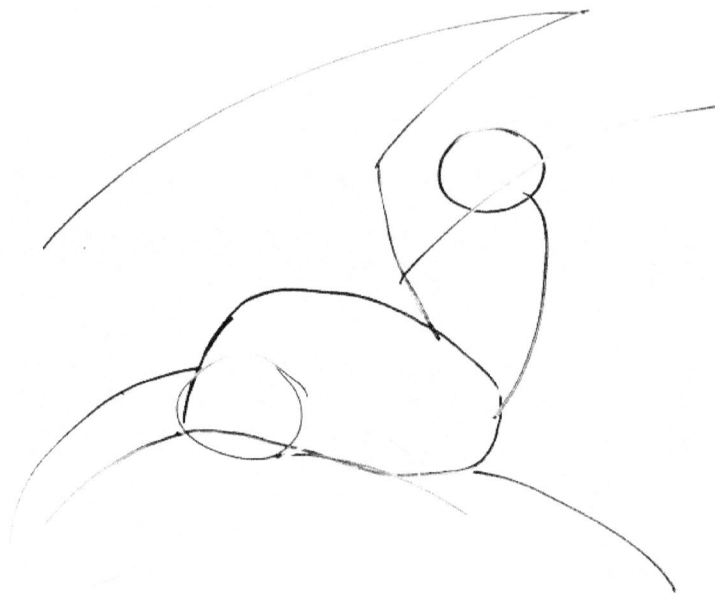

Fig. 14. Geometrical foundation of our dragon.

Once you have finished, bring your focus to the head. In contrast to the Asian dragon, the Western dragon is bony and structured. It has a more defined skulled. So, let us sketch a few shapes here and there to define this structure. Here is a template of what the structure of a dragon head might look like:

Fig. 15. 1) Temples and eyes, 2) jaw, 3) nozzle and mouth.

Remember that this is just a guide. You can always re-structure this to

conform to what your imagination fancies.

Depending on what you have in mind, you can place fan-like appendages behind the ears or horns that extend from its temples. Think out of the box!

With these shapes as "guides," let us now connect the "actual" structure of the head. With this guide, I restructured the geometrical pattern to what best suit's the picture I have in mind. And here's what I came up with:

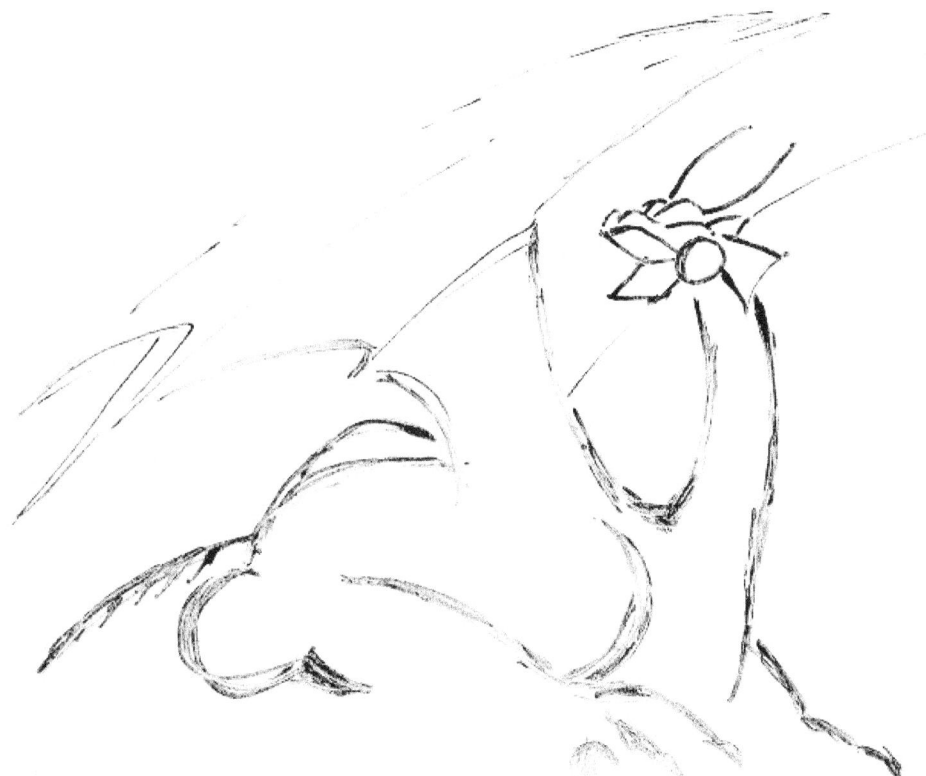

Fig. 16. Add more details using a light-grade pencil such F or H. Otherwise; simply lighten the pressure exerted on your pencil.

Form Construction - contour

Having established the basic construct of our Western dragon, let us proceed with creating more flesh. Similar to the process earlier, we will put more definition by drawing the key features.

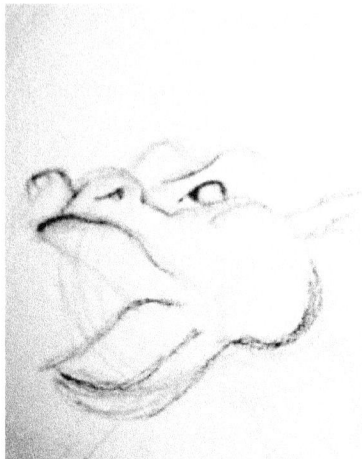

Fig. 16. Basic facial features. Use an HB pencil at this point. This helps you differentiate the "guide lines" created using an H pencil, and those from the actual lines that establish the facial features.

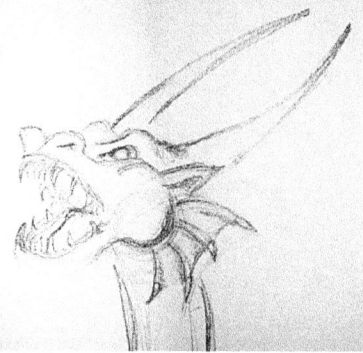

Fig. 16. A more detailed and "ornamented" dragon head. I went on to define more of the facial features to include the teeth, ears, horns, and fan-like appendages.

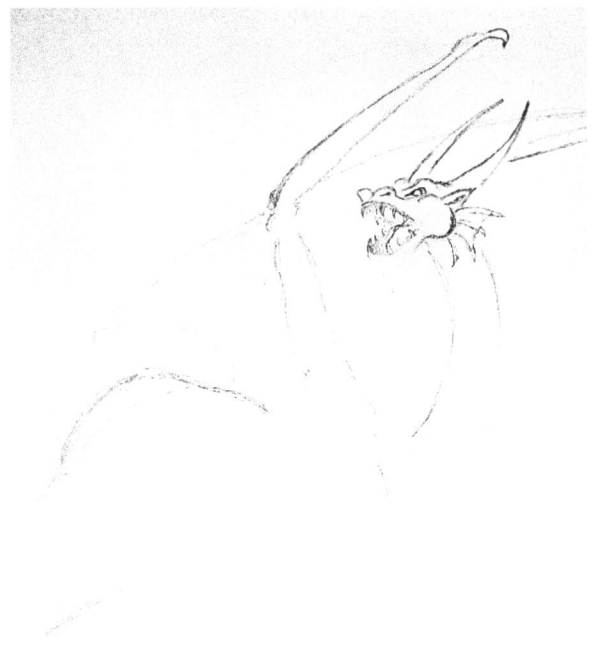

Fig. 17. The head, body, and tail are reptilian in nature. The structure is not a far cry from that of a lizard or dinosaur.

Detailing

Now, our dragon will really come into shape. Taking a 4B pencil, let us further define the structure and details of each aspect.

The eyes are unlike Asian dragons. The pupils are diamond in shape. But if you choose to draw a friendly dragon, you may choose to deviate from this. Round pupils are more amiable than diamond ones, which can be threatening. For this dragon, the eyes are not close enough to define. Thus, the shape of the pupil does not really influence how threatening it might look. This is why it would be a good idea to focus on other features, which are more visible. I went on and added more features, which would create a regal effect rather than a formidable one.

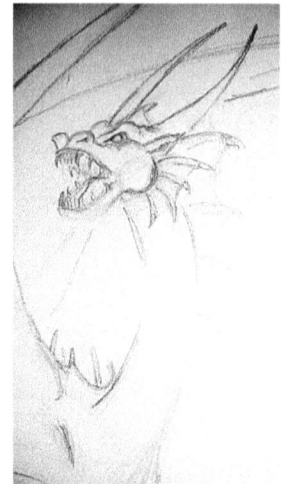

Fig. 18. To create a regal Sea or Water Dragon, I added more fan-life appendages.

Let us proceed further with other body features.

The lower body corresponds with that of other four-legged creatures. However, you might have noticed dragons that seem half-human and half-beast, wherein their bodies are similarly structured to humans. This enables them to move more like humans rather than like beasts.

The following barebones offers two opposing leg structures, which you could experiment with:

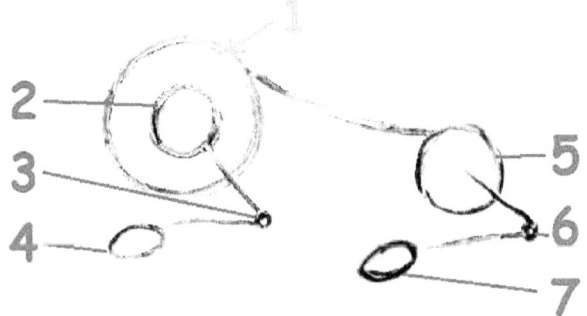

Fig. 19. 1) Torso or chest, 2) shoulder, 3) elbow, 4) hand/paw, 5) hip bone, 6) knee, 7) foot/paw.

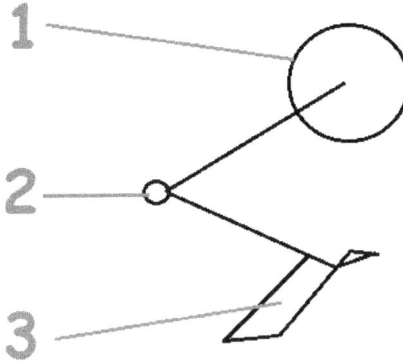

Fig. 20. 1) hip, 2) knee, 3) foot.

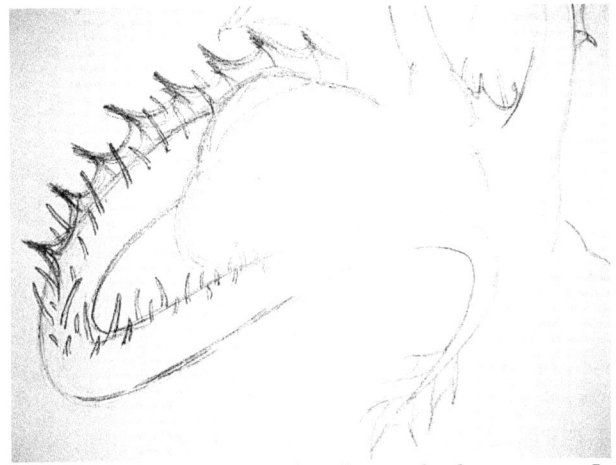

Fig. 21. Before proceeding with other lower body aspects, I added more features to the tail. This is because the tail comes in front of the lower body. This allows me to establish the features which will actually be visible to the viewer. Working on the aspects that fall on the background will be time-consuming for one reason: they may just be deleted later on because they get in the way of features that appear in front of them. In this case, the tail comes in front of the lower body, leg, and much of the foot.

Once you are satisfied with the results, you can proceed with outlining with a pen and coloring. Take a tracing paper and begin outlining over the original drawing. Then, set aside the first layer. Save it as a template. Then, proceed with coloring the second layer.

However, I would suggest you set it aside as we proceed with another topic: Rendering.

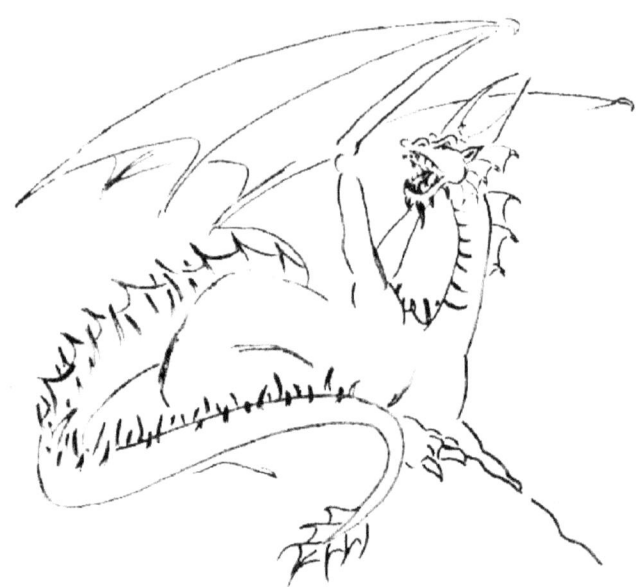

Fig. 22. Outline of our Western Dragon.

Rendering

Another phase in drawing you might want to look into is *rendering*. Rendering can refer to two things: 1) shadowing, and 2) the degree of realism of an artwork. They are not one and the same although they are interdependent.

While the first can stand alone, the second may or may not involve the first. The latter refers to the amount of *detailing* done—it is not confined to shading. Instead lines and other minutiae integrated.

Every drawing begins as flat and two-dimensional, consisting of nothing but shape and form. Then, we build on this construct. Before we do so, we decide how realistic we want our drawing to be. Here is a simple trick: Cartoon is to Simplified; Realistic is to Intricate. Cartoon and comic style drawing lean towards the simple and flat. Realistic drawings lean toward the meticulous and elaborate. As you can imagine, moving from simple to realistic involves a lot of work. The task becomes more tedious. The more lines, wrinkles, and scales we draw on our dragon, the more real it becomes. And by applying *shading* techniques, we create the illusion of depth and dimension. Our two-dimensional dragon transcends itself into three-dimensionality.

The proceeding section discusses rudimentary methods that will greatly improve your skills.

Basic Rendering Exercises

Another common exercise is associating the different parts of the subject with different shapes. If you have taken the time to study your subject, the different regions are very similar to various geometrical figures. Such would be curved planes, circles, spheres, and cylinders.

This exercise will be most beneficial to rendering. There is nothing special required to perform this exercise. You could use everyday objects. It would be a good idea to start out with a ball or orange. It has no frills or fancy whatnot about it. All there is to it is its round, smooth surface. So, all you need to draw is a simple round shape.

It would be a good idea to use natural lighting for this exercise. It is ideal to sit by a window. Place your object on the ledge. Make certain that one side is dark, gradually brightening towards the other side, creating a gradient effect.

If natural light is not available, take a lamp and position your subject in a way in which you can achieve the best contrast possible. If moving the source of light or subject is challenging, simply change your vantage point by re-positioning yourself instead.

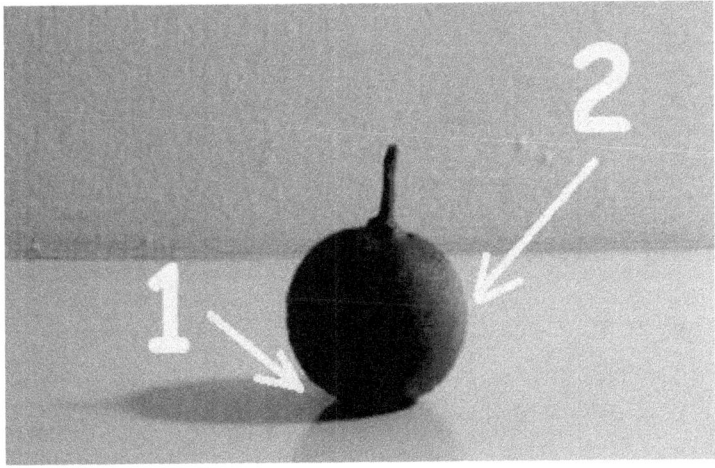

Fig. 23. 1) A dark form called the cast shadow falls behind the object, opposite the source of light. 2) The area closest to the source of light naturally appears brighter than other areas.

There are several shading techniques: hatching/cross-hatching, squiggly lines, cross contour, blending, and rendering.

Perhaps the best known techniques are hatching and cross-hatching. The former is done by drawing straight lines for shadows, while the latter is done by drawing a nest of horizontal, vertical, and diagonal lines.

Instead of straight lines, the squiggly technique uses circular patterns, though; you need not confine yourself to circular lines. The point is creating alternating, overlapping patterns. Still, keep the contrast of shadows in mind.

Similar to hatching, cross contour uses lines to render. The difference lies in the strict use of slanted lines, giving off more perspective and dimension than hatching.

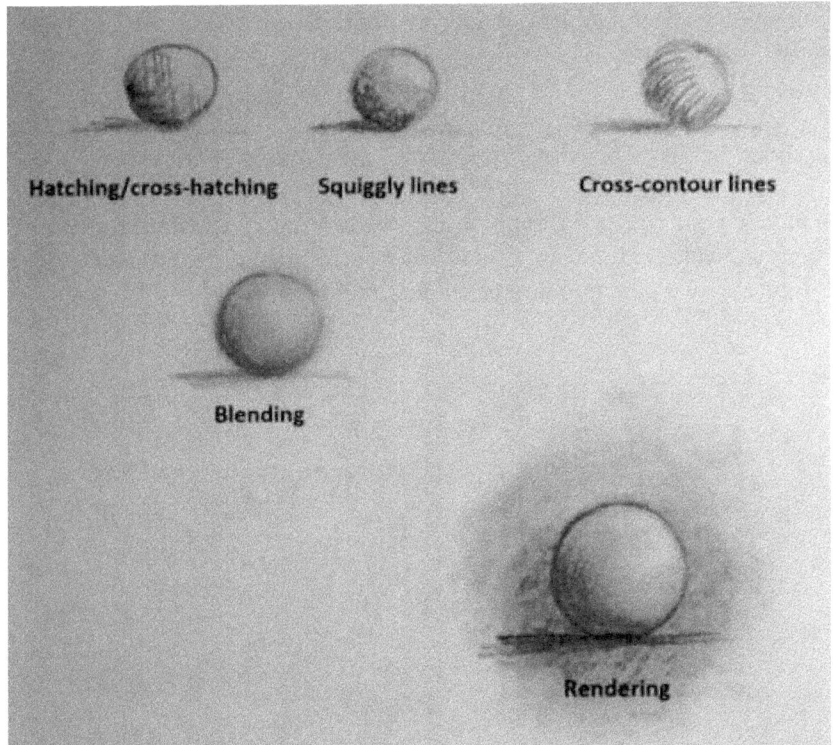

Fig. 24. Different kinds of shading: 1) hatching and cross-hatching, 2) squiggly lines, 3) cross-contour, 4) blending, and 5) rendering.

To achieve a more proficient look, blending and rendering might be your preferred techniques. A close contender to hatching, blending is actually commonly used. Self-taught, natural-born artists use this instinctively. You may have been doing it yourself.

Blending is achieved using a single grade or several grades of pencils. When using one grade (HB, for example), simply vary your pressure to lighten or darken areas. When using several grades, you may use two to three grades (perhaps an HB, 2B, and 6B). Using more grades provides you with a broader value scale. Then, use a tortillon or brush to blend the shadows.

Finally, rendering is the trickiest technique. It requires a degree of proficiency—unless it comes naturally for you. In fact, rendering could be deemed a drawing technique rather than a method for shadowing.

Unlike all the other methods, rendering primarily uses the eraser, instead of a pencil, for drawing. A pencil is still used but only for outlining and additional shading.

To render, begin by covering the drawing area with positive value.

Then, take your eraser and rub out the area that represents the general form of your subject. With the aid of a tortillon, smoothen out the shadows within the figure. Use a pencil to darken the figure's outline and add further contrast.

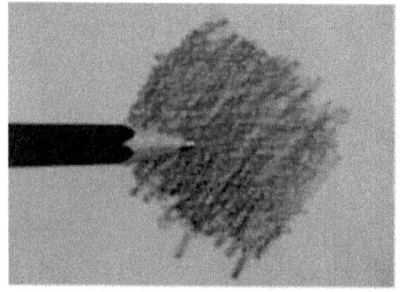
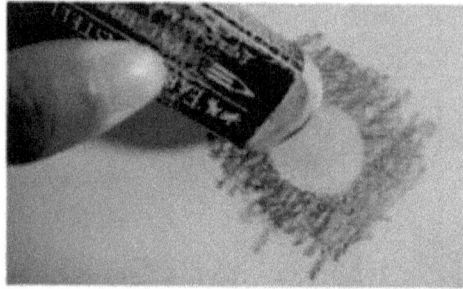
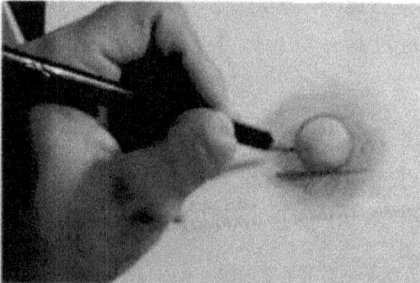

Fig. 25. Rendering as a drawing and shading technique. First, put in some volume. Second, use the eraser to create some negative space in the form of the object. Use the tortillon to blend the shadows and the pencil to emphasize the shape.

During the course of the exercise, you may want to experiment with your pencils and explore their possibilities. Mostly, the varying grades give you a wider range of monochromatic color value (in contrast to using a single pencil and changing the pressure you exert for contrast). In the same way, using varying tints and hues produces a broader scope of chromatic value.

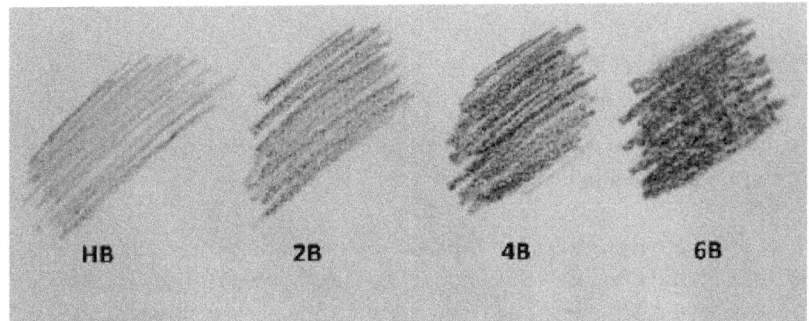

Fig. 26. Value scale from HB to 6B. Graphite pencils within the B grade range contain more graphite than clay. This makes them perfect for outlining and rendering because of their darker tones and value compared to H and F pencils.

Dragon Rendering

Now, let us take a look at how we can use rendering to give our dragon more depth and dimension.

To proceed, take the "dragon template" we set aside earlier. Place a tracing paper over it and create a second dragon. The first was a friendly dragon with round eyes. This time, let us tweak it a bit here and there. Give it more edge. By doing so, we give it a more robust, brawny personality.

At this point of the drawing process, the most logical technique to adapt is *blending* (because we already have a drawing to work with.) Moreover, we want to mold our dragon into something realistic.

Let us start with shading and shadowing. Establish the source of light by drawing a small spotlight to aid your imagination. Then, mark the areas were shadow is most likely to fall. Using a 4B pencil, start shading these areas, and remember that the region farthest from the light is logically darker than the areas closer to the light.

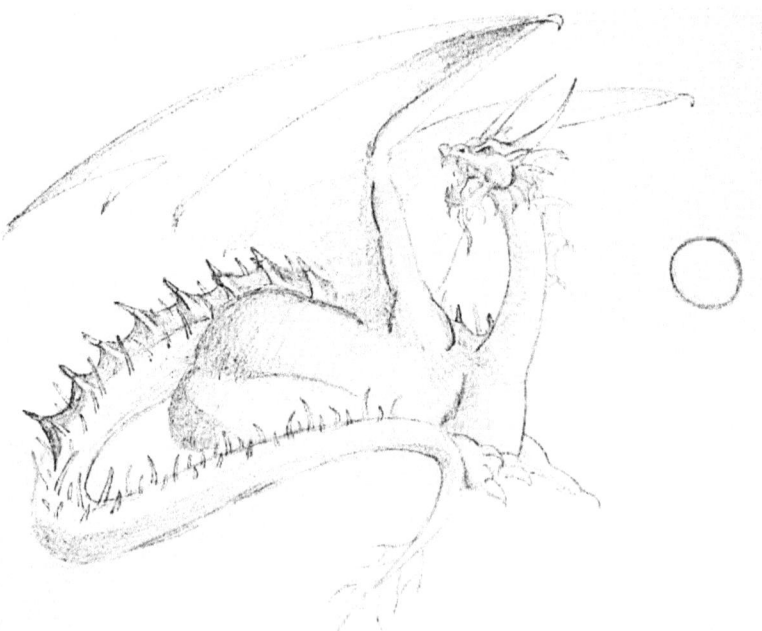

Fig. 27. Marking the area of the shadow, ensuring that a gradient effect from darkest to lightest is achieved. Use a blending stump to create a gradient effect.

Fig. 28. I further darkened the shading to really create more dimension. I also drew a background to establish the scene and aid with rendering.

Fig. 29. The neck is usually serpentine in nature. Some artists like to pattern it after a crocodile's as well. Since this is a Water Dragon, I wanted to achieve a look that is more majestic than formidable. It may appear fearsome in real life, but it would be too exquisite that the viewers would be drawn back and overwhelmed with intense admiration before they could realize what kind of creature is standing before them... before they could stand frozen in panic.

Fig. 30. As for the body, take a 4B pencil and draw rugged, curved vertical lines to create texture.

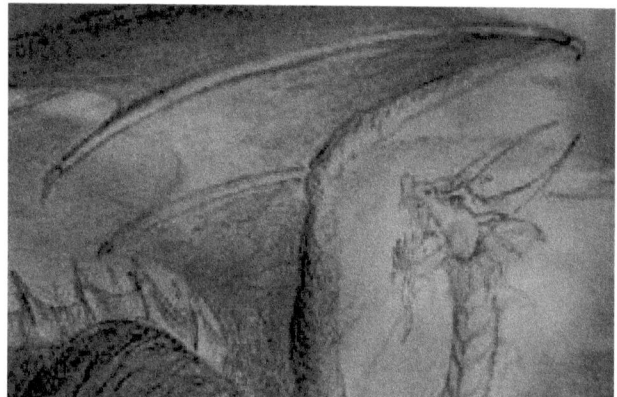

Fig. 31. On the inner side of the wings, draw vine-like lines.

By lightly erasing small areas, we create blemishes. With the aid of a pencil and blending stump, we can further define these areas.

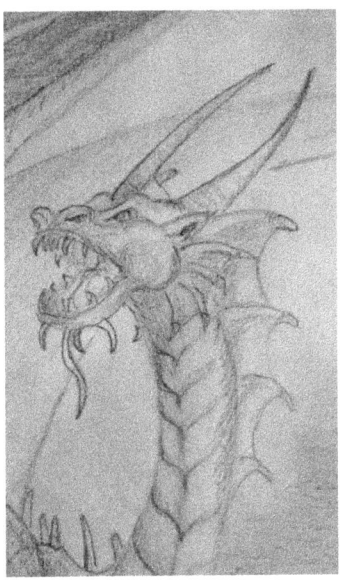

Fig. 32. It is a good idea to draw the same rugged, curved lines on the horns to make it appear more realistic.

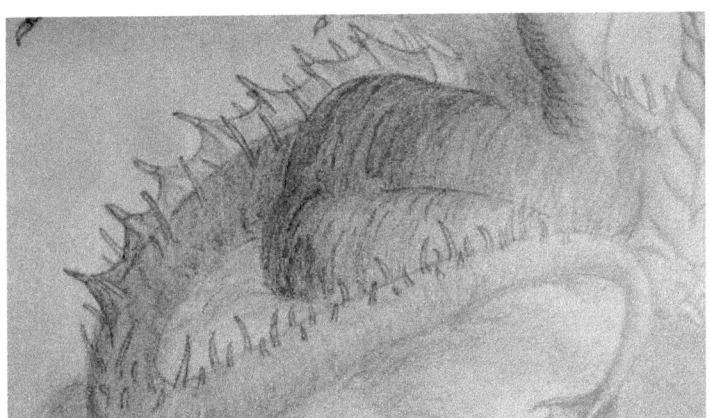

Fig. 33. The protrusions on the dragons back and tail may have lost definition due to blending. Use a 6B pencil to outline them again.

Fig. 34. Use a kneaded eraser to brighten areas. Another benefit of working with a kneaded eraser is that you can use it to create texture in a way that regular erasers cannot offer. Although shading creates dimension, it does not really give establish the quality of a given area. Usually, you will simply come up with a smooth, consistent surface. But in real life, nothing is without flaw. By building up variety and inconsistencies, your subject becomes more dynamic and genuine.

Now, we are ready to make final touches. Here is an optional blending trick. Blending stumps can create harsh shadows. Depending on the quality you want to achieve, there really is no problem with this. But sometimes, I want my work to come out as a smooth finish. Sort of make it appear like a printout. To achieve this effect, I take a size 1 paintbrush and lightly sweep over the drawing to soften the shadows. Just be really careful not to create unnecessary smudges. With caution and practice, you can really use this neat trick to your advantage.

Let us take a look at the final results.

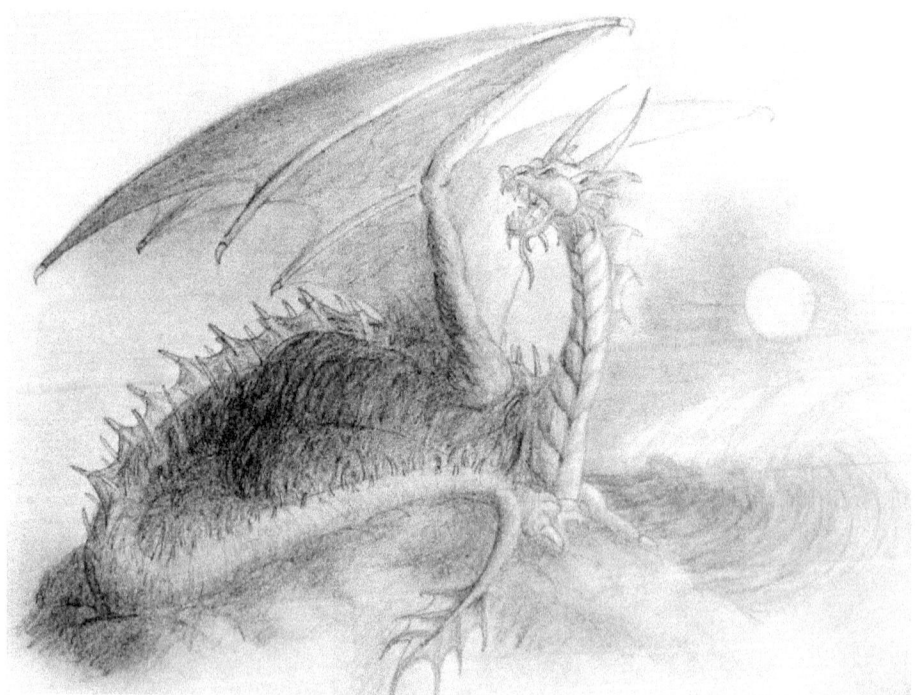

Awesome work! Congratulations! Apart from journeying through the mystical worlds of dragons, you have also learned key techniques on how to draw your own fire-breathing beast!

Glossary

Blending. Fusing together a diversity of colors, textures, media, or values. Graphite and charcoal drawing would generally focus on the mixing of value scales when rendering.

Cast shadow. This refers to the shadow of an object shed on a surface. It is the dark region beneath the object. This naturally happens when a light is placed before an object.

Chromatic value. The degree of lightness and darkness colors exhibit.

Contour. A drawing style that focuses on creating outlines of the subject. This can also refer simply to the outline of the object.

Contrast. The distinction between light and dark.

Depth. Intensity or illusion of space.

Figure drawing. Illustrating the whole human figure.

Geometric shapes. Figures with well-defined boundaries.

Illusion. A visual or perceptual deception that alters a viewer's sense of space or object.

Length. The longitudinal measurement of an object. The numerical value of space occupied by an object vertically.

Monochromatic color value. A single color or hue with a complete range of chromatic value.

Negative. Refers to the space surrounding an object.

Positive. Refers to the space occupied by an object.

Process. In drawing, it refers to the manner by which an artist produces a work of art. This differs from one artist to another. Discover what process works best for you.

Realism. A realistic representation of the subject in its most natural form.

Realistic. Real and not conceived through imagination.

Sketch. Making light drawing marks usually referred to as a practice to drawing.

Subject. The central figure of an artwork, animate or inanimate.

Technique. The manner in which tools and materials are used to produce a work of art.

Three-dimensional. In drawing, these are forms that create the illusion of depth. They possess height, width, and volume.

Tone. Shades of a color or hue.

Two-dimensional. Forms that have height and width, but lack volume. Therefore they appear flat.

Value scale. A scale that shows the range of values from lightest to darkest

Vantage Point. Point of view of the artist or from which a subject is viewed.

Variety. An assortment of elements, differing degrees, or diversified values within a composition.

Vertical. Direction that runs up and down or from top to bottom.

Volume. The space covered by an object. Space that is measured by the amount of matter that covers it.

Width. The horizontal measurement of an object. The numerical value of how much length an object spans.

The Author and Artist

Writer and Visual Artist Jonalyn Crisologo completed her degree in Bachelor of Arts in Communication at the Saint Louis University. In the past ten years, she has been writing for print and Web publishing. As an artist, she has a penchant for conventional art. In spite of this, she considers digital tools quite handy. An avid reader, she is fond of graphic novels and pop-up books. Stan Lee, Walter Moers, Maurice Sendak, and Brothers Grimm are just a few of her favorite illustrators.

This book is published by

JD-Biz Corp

P O Box 374

Mendon, Utah 84325

http://www.jd-biz.com/

www.ingramcontent.com/pod-product-compliance
Lightning Source LLC
Chambersburg PA
CBHW071824170526
45167CB00003B/1407